"Blessed are those who wash their robes,
that they might have the right to the tree of life,
and may go through the gates to the city."

Revelation 22:14 (NIV)

Design and illustration by Steve Rigley

Solway is an imprint of Paternoster Publishing, P.O. Box 300, Carlisle, Cumbria CA3 0QS U.K

British Library Cataloguing in Publication Data
A catalogue record of this book is available from the British Library.

ISBN 1-900507-62-5

Printed in the U.K by BPC Wheatons Ltd., Exeter.

Impressions of Heaven

CITY of GOLD

Featuring the words of
Adrian Plass, John Bunyan, C. S. Lewis,
J. John and others

solway

Do you think much about heaven? Have you been lulled into boredom by the insipid idea that we will be sitting on clouds playing harps?

Are we like the little girl who said, 'Heaven is a nice place, but nobody is in a rush to get there?'

Heaven is one of the most misused religious ideas around today. That is, if you do believe in heaven. Some people take their lead from John Lennon, 'Imagine there's no heaven, it isn't hard to do....'

Whatever you believe or don't believe about heaven, I invite you to suspend judgment and wonder with me what the implications might be if what the Bible says is true. Of course, it is true that the idea of heaven has been used as a threat, as some strange distant place which if you want to go there some day, 'Well, you just better get your act together so you might be able to bargain yourself in.'

Heaven in the Bible is not a place in the blue beyond. Heaven is God's space; it's the full reality of God. We catch glimpses of God's space all over the world, but it is not established here.

It is not that earth is real and heaven is less real, but rather that what we are living in now is less real compared to what will be. The writer C.S. Lewis talked about this earthly life as being the 'shadowlands'. This life, the colours we see, the good we experience, the joy we have, the pleasures we know - these are as minor shadows compared to the extraordinary colour, beauty, joy and delight of heaven. We haven't seen anything yet - this is just like the warm -up kick -around before the football match really begins.

Earth is really heaven's dress rehearsal. But what will it be like? And how can we be sure?

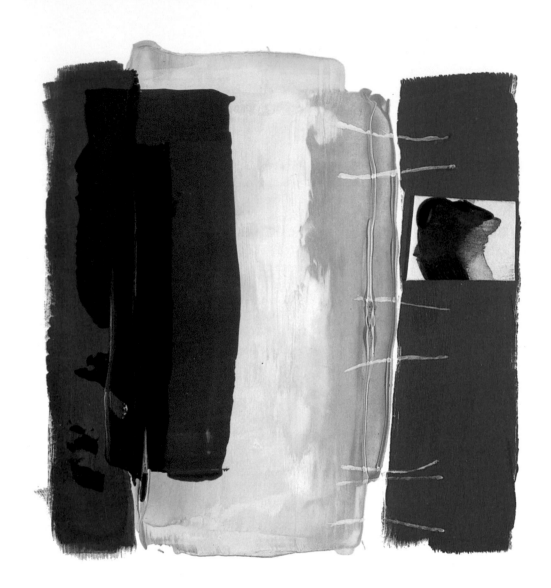

Just as the gates were opened to let in the pilgrims,
I looked in after them;
And behold, the city shone like the sun,
And the streets were paved with gold.
Inside walked many people, with crowns on their heads,
Palms in their hands, and golden harps to sing praises.
When I had seen, I wished myself among them.

John Bunyan - THE PILGRIM'S PROGRESS

The Golden City

Soon your trials will be over
Offered up by mercy's hand
A better view from where you're standing
A doorway to another land

The sweetest welcome from the Father
Gathered up and carried home
We are past the time of waiting
Come let us bow before Your throne

We will meet in the Golden City
In the New Jerusalem
All our pain and all our tears will be no more
We will stand with the hosts of heaven
And cry 'Holy is The Lamb'
We will worship and adore You evermore

Never can the powers of darkness
Neither death, nor even life
Let nothing ever separate us
From the Holy Love of God

Creed

I cannot say my creed in words,
How should I spell despair, excitement, joy and grief,
Amazement, anger, certainty and unbelief?
What was the grammar of those sleepless nights?
Who the subject, what the object
Of a friend who will not come, or does not come,
And then creates his own eccentric special dawn,
A blinding light that does not blind?
Why do I find you in the secret wordless places
Where I hide from your eternal light?
I hate you, love you, miss you, wish that you would go,
And yet I know that long ago you made a fairy-tale for me,
About the day when you would take your sword
And battle through the thicket of the things I have become.
You'll kiss to life my sleeping beauty waiting
for her prince to come.
Then I will wake and look into your eyes and understand
And for the first time I will not be dumb
And I shall say my creed in words.

Adrian Plass

How Lovely is Your Dwelling Place

Surely you and I should know
It's written on the Earth below
That every good and perfect gift
Is sent from Heaven above

It's written on a newborn smile
When friends will call or stay awhile
It's written on a giving heart
For all the world to see

Sometimes my soul will yearn
to reach another land
Where all these moments meet
are free in time and space
So let the mountains sing
and let the waters speak
and tell how sweet and lovely
is your dwelling place

It's written on the leaves of green
It's written on a sky of blue
When Autumn brings it's fields of gold
It's written there for you

Playground

Oh, God, I'm not anxious to snuff it,
But when the grim reaper reaps me,
I'll try to rely on my vision of Zion,
I know how I want it to be.
As soon as you greet me in Heaven,
And ask what I'd like, I will say,
'I just want a chance for my spirits to dance,
I want to be able to play.'

Tell the angels to build a soft playground,
Designed and equipped just for me,
With a vertical slide that's abnormally wide,
And oceans of green PVC.
There'll be reinforced netting to climb on,
And rubberised doors that will bend,
And no-one can die, so I needn't be shy,
If I'm tempted to land on a friend.

I'll go mad in the soft, squashy mangle,
And barmy with balls in the swamp,
Coloured and spherical – I'll be hysterical,
I'll have a heavenly romp.
There'll be cushions and punchbags and tyres,
In purple and yellow and red,
And a mushroomy thing that will suddenly sing,
When I kick it or sit on its head.

There'll be fountains of squash and Ribena,
To feed my continual thirst,
And none of that stuff about, 'You've had enough',
Surely heavenly bladders won't burst.
I might be too tall for the entrance,
But Lord, throw the rules in the bin,
If I am too large, tell the angel in charge,
To let me bow down and come in.

Adrian Plass

Angels at Dunblane

Where were you when evil visited Class P1?
Were you not alert, on guard
While the innocents fumbled with gym shoes
And chattered contentedly, unaware of the darkness?
When the violent sounds of pistol
Stole so many precious lives
Could you not shield with mighty wings
And slay the evil?
Could you not restrain such deadly demons
That carry the stench of hell into such heavenly sweetness?

These Gethsemane questions are beyond our knowledge
But know this:
That when those sweet flowers fell shedding crimson petals
We were there
Gathering such a bouquet as heaven seldom saw.
We overflew cold Calvary and heard again the cry of desolation,
Yet also saw the open tomb
And we danced together with those young
In the glory fields of Paradise.
One of us looked back to those bleak school gates
And saw white flowers arranged with caring hand
to bear the name 'Angels'.
We marvelled that we could be honoured thus
To be compared to such noble lives.

Michael Mitton · 13th March 1996

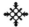

As they went on their way, they came to a pleasant river, The River of The Water of Life. Their way lay just upon the bank of the River; here therefore they walked with great delight. They drank also of the water of the River, which was pleasant and enlivening to their weary spirits. On the banks of this River were green trees, bearing all manner of delightful fruit. On either side of the River was also a Meadow, curiously beautified with Lilies and green all the year long. In this Meadow they lay down and slept, for here they might lie down safely.

John Bunyan - THE PILGRIM'S PROGRESS

The Bells of the City Rang

In the shadows of the evening fire
At the closing of the day
Many tales were told
From the travelling road
Of a world so far away

Of a peaceful place
Where children played
How they laughed and how they sang
As they danced beneath the pearly gates
And the Bells of the City Rang

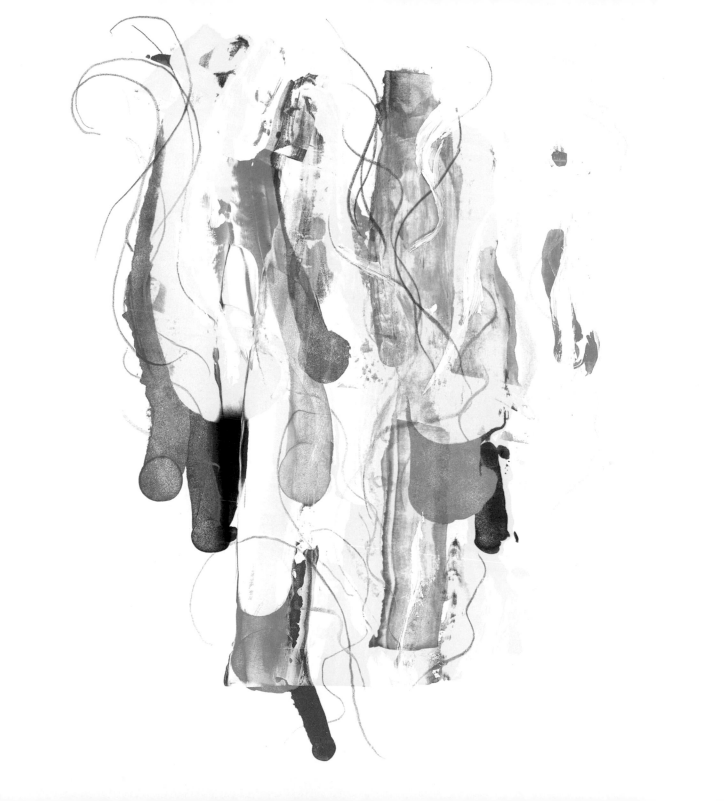

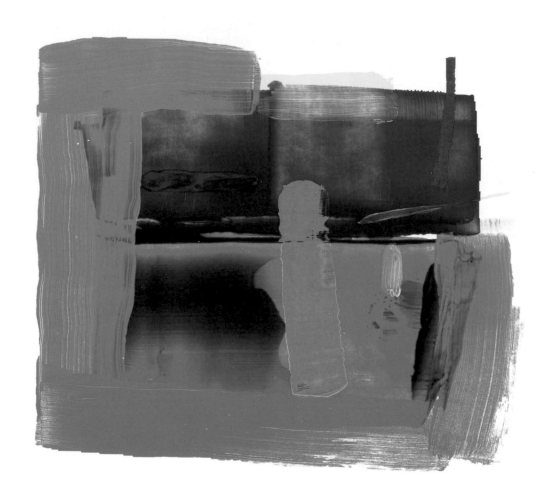

WE were made for God. Only by being in some respect like Him, only by being a manifestation of His beauty, lovingkindness, wisdom or goodness, has any earthly Beloved excited our love. It is not that we have loved them too much, but that we did not quite understand what we were loving. It is not that we shall be asked to turn from them, so dearly familiar, to a Stranger. When we see the face of God we shall know that we have always known it. He has been a party to, has made, sustained and moved moment by moment within, all our earthly experiences of innocent love. All that was true love in them was, even on earth, far more His than ours, and ours only because His. In Heaven there will be no anguish and no duty of turning away from our earthly Beloveds. First, because we shall have turned already; from the portraits to the Original, from the rivulets to the Fountain, from the creatures He made lovable to Love Himself. But secondly, because we shall find them all in Him. By loving Him more than them we shall love them more than we now do.

C. S. Lewis

Duntulm Bay

IT was going to be one of those 'shooting star nights' in late July, as we watched the sunset over the Western Isles. The talk was happy and peaceful, of the day that had been, of friends, and high places. The conversations continued as the wine was opened and the food was cooking over an open fire.

Slowly as the night unfolded, we began to wish that this moment in time would stand still forever, the sense of true happiness and contentment was almost overwhelming.

The night was warm, as was the company, as we ate, drank, talked and laughed till we cried.

Later, guitar in hand, we began to sing and sing at the top of our voices, songs we hadn't sung for years, before lying back to watch the stars and listen to the waves coming home to shore.

The quietness was broken by a beautiful, yet mysterious sound rolling back to us from the hills behind the bay, a perfect echo of the songs. It was almost as if the angels had decided to join the occasion. We tried in vain to repeat the same but to no avail.

So we laughed and talked some more, gathered out thoughts and memories together, and headed home.

A glimpse of heaven, some might say, or just a beautiful night down at Duntulm Bay.

Phil Baggaley

Down here, up there

Down here - we've got peace treaties with guns
down here - we've got luke warm hot-cross buns
down here - we've got Porsches, pearls and slums
a mishmash of massed mortals mope down here

Down here - we wear tinsel, tat and tweed
down here - we say creeds we'll never need
down here - we've got Bill and Ben and Little Weed
the jumble sale called life is what's down here

Up there - there are trees and flowers that fly
up there - gorillas stroll the sky
up there - is the dolphin's liquid cry
starfish ceilidh daily way up there

Up there - there's a sapphire sun at dawn
up there - countless clouds of never born
up there - ride the Golden Unicorn
the child that never was is named up there

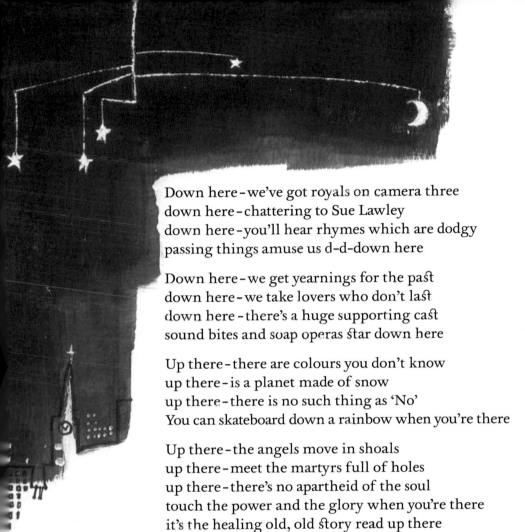

Down here - we've got royals on camera three
down here - chattering to Sue Lawley
down here - you'll hear rhymes which are dodgy
passing things amuse us d-d-down here

Down here - we get yearnings for the past
down here - we take lovers who don't last
down here - there's a huge supporting cast
sound bites and soap operas star down here

Up there - there are colours you don't know
up there - is a planet made of snow
up there - there is no such thing as 'No'
You can skateboard down a rainbow when you're there

Up there - the angels move in shoals
up there - meet the martyrs full of holes
up there - there's no apartheid of the soul
touch the power and the glory when you're there
it's the healing old, old story read up there
the lamb, the lion and scapegoat reign up there.

Stewart Henderson

The King Who Remembers My Name

All that you are
is faithful and true,
In justice the judgement is fair.
All that I have
is free love that you gave,
It's mercy that brought me to here

The Armies of Heaven
are riding behind you
Clothed in fine linen
Washed whiter than snow

As Crowned in your Glory
you ride the white horse
with eyes like a forest in flame
But through Majesty's ways
its your grace that endures
The King who remembers my name

Kingdoms may rise
Kingdoms may fall
The word of the Lord will not change
The King that I serve
Is the Lord over all
Eternally, age upon age.

Cricket

I'm dying to live after living has ended,
I'm living for life after death,
Alive to the fact that I'm dead apprehensive,
I'll live to the end of my breath.
But what would life be were I no longer living,
And death was no longer alive,
How would I stick it without any cricket,
How would I ever survive?
Would I cross swords on some heavenly Lords,
With the angels of Holding and Hall,
Would I face up to Lillee without feeling silly,
And even catch sight of the ball?
Would a man with a beard whom the bowlers all feared
Redeem us from losing – a sin?
Yes, by Grace we'd be saved as his century paved
The way to a glorious win.
I promise you, Lord, I'll never get bored,
I'll practise the harp, there, I've sworn,
If cricket's allowed, I'll be back on my cloud,
The moment that stumps have been drawn.

Adrian Plass

Safe in Your Harbour

The wandering of a traveller
The many miles I've roamed
This spirit of adventure
Is ready for a home

I've been battered on the east side
I've been beaten to the west
Soon this ship is sailing
Towards a place of rest

So safe in your harbour
Where storms rage no more
A true sanctuary
At peace on Your shore

A shadow of the beautiful
A world that is to come
The promise of a resting place
When all our work is done

Something to look forward to...

THE other day a group of us were talking about heaven. I was putting forward the view that the quality of eternal life will be much more closely linked to our lives on earth than we imagine. 'Surely the essence of all those beautiful things in the world must be there because they're part of him and part of us. I reckon anything good and innocent and beautiful down here has a chance of surviving in some form up there. For instance, I fully expect to play cricket in heaven.'

'Well, I'm not going then,' said one of the ladies spiritedly. 'If you think I'm going to watch cricket in heaven you've got another think coming. It already lasts forever down here.'

'No, no,' I protested, 'you won't have to. Each of us has got our own list of things that mean a lot to us. We won't have to get involved in anything we don't like.' Most of us had contributed something to this enjoyable if highly speculative discussion but there was one chap, lets call him Jim, who had said nothing. Jim was a man who really loved Jesus but his language and general conversation in this context tended to be abstract and rather unimaginatively Bible-based. He listened to our discussion with a little smile of gentle scepticism on his face.

'It's quite a thought, isn't it,' said someone else, 'that we might be allowed to do or have the very thing we've always wanted most and never been able to have?' I was just about to answer when I noticed the smile had gone from Jim's face. In its place was an expression of what appeared to be deep spiritual longing. Rarely have I seen anyone with as much of his heart in his eyes as I saw in Jim's at that very moment. Probably some Bible verse, I thought, that will neatly dismiss everything we've been saying. 'Penny for 'em, Jim,' I said.

'Oh!' He seemed to come to with a start. 'I was just thinking how much I've always wanted...' The far-away look came back into his eyes. 'I was just thinking how absolutely wonderful it would be if he would let me have, well a lathe of my own...'
Somewhere in heaven a note was made.

Adrian Plass

No Song on Earth

No song on Earth will ever sound
Like one before your throne
When myriads of the Angels sing
In Praise to you alone
No morning Sun
No Harvest Moon
or Star can shine so bright
There's nothing can compare with this
our sweet eternal light

No city on this Earth will stand
for all eternity
the beauty of this Promised Land
a welcome there for me
beyond this noise to peace at last
at rest beside your throne
No city can compare to this
and our eternal home

No kingdom knew of such a King
of one so true and brave
who laid aside his diadem
for those he came to save
Oh matchless love
such mercy free
I cannot comprehend
There is no one compares to Thee
my master and my friend

Heaven

When I'm in heaven
Tell me there'll be kites to fly,
That kind they say you can control
Although I never did for long,
That kind that spin and spin and spin and spin
Then sulk and dive and die,
And rise again and spin again,
And dive and die and rise up yet again,
I love those kites.

When I'm in heaven
Tell me there'll be friends to meet,
In ancient oak-beamed Sussex pubs
Enfolded by the wanton Downs,
And summer evenings lapping lazily against the shore
Of sweet familiar little lands
Inhabited by silence or by nonsenses,
The things you cannot safely say in any other place,
I love those times.

When I'm in heaven
Tell me there'll be seasons when the colours fly,
Poppies splashing flame
Through dying yellow, living green
And autumn's burning sadness that has always made me cry
For things that have to end.
For winter fires that blaze like captive suns
But look so cold when morning comes.
I love the way the seasons change.

When I'm in heaven
Tell me there'll be peace at last,
That in some meadow filled with sunshine
Filled with buttercups and filled with friends
You'll chew a straw and fill us in on how things really are,
And if there is some harm in laying earthly hope at heaven's door,
Or in this saying so,
Have mercy on my foolishness dear Lord,
I love this world you made - it's all I know.

Adrian Plass

This is Your Land

Didn't anyone ever tell you
Didn't anyone ever say
Did you capture a vision of glory
As she held out her hand today
It's reaching to the broken ones
Right down to where you stand
Didn't anyone ever tell you
This is your land

Didn't anyone ever tell you
Doesn't matter, the last will be first
For the sad and the meek and the righteous
And all those who hunger and thirst
So let the poor in spirit know
These dreams are not of sand
Didn't anyone ever tell you
This is your land

You'll be given the robes of Princes
You'll be flying on golden wings
You will live in pavilions of splendour
Be surrounded by beautiful things
So hold on to these promises
And keep them in your hand
Didn't anyone ever tell you
This is your land

Homeland

'Do you see the mystery of our pain?
That we bear poverty
And are able to sing and dream sweet things.'

Ben Okri – African Elegy

We're heading for a clearing
where the scrub is made of jade
it's a place of sweet aroma
where who we are is weighed
though none of us can walk it
and very few can crawl
we're on our way towards it
as we hear the Shofar call

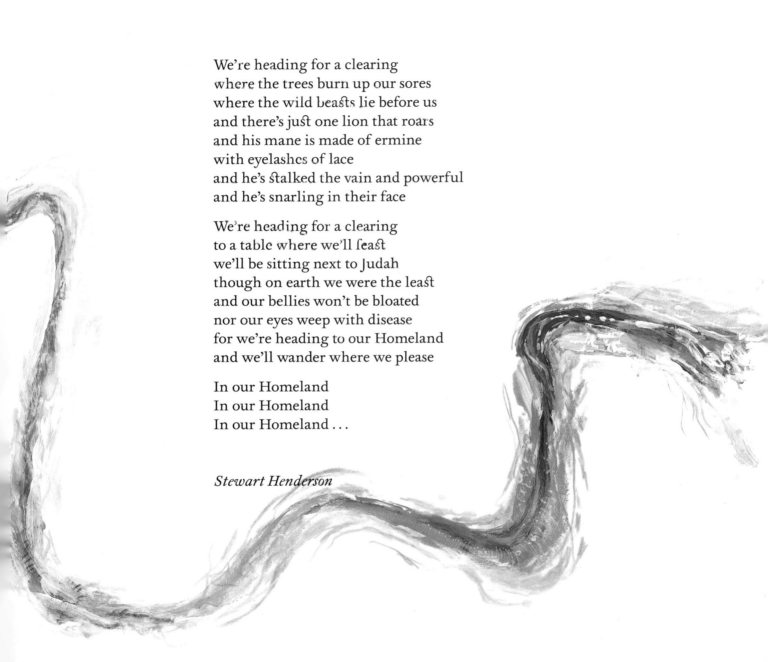

We're heading for a clearing
where the trees burn up our sores
where the wild beasts lie before us
and there's just one lion that roars
and his mane is made of ermine
with eyelashes of lace
and he's stalked the vain and powerful
and he's snarling in their face

We're heading for a clearing
to a table where we'll feast
we'll be sitting next to Judah
though on earth we were the least
and our bellies won't be bloated
nor our eyes weep with disease
for we're heading to our Homeland
and we'll wander where we please

In our Homeland
In our Homeland
In our Homeland . . .

Stewart Henderson

Now while they were thus drawing towards the Gate, behold a company of the Heavenly Host came out to meet them. There came out also at this time, several of the King's Trumpeters, clothed in white and shining Raiment, who with melodious noises, and loud, made even the heavens to echo with their sound. These Trumpeters saluted the pilgrims with ten thousand welcomes from the world, with shouting and sound of trumpet, signifying how welcome they were into their company, and with what gladness they came to meet them.

Now, when they came to the Gate, the pilgrims each handed in their Certificate, which they had received in the beginning; these therefore were carried into the King, who, when he had read them, said, Where are the pilgrims? to whom it was answered, They are ſtanding outside the Gate. The King then commanded to open the Gate.

Now I saw in my dream, that these pilgrims went in at the Gate; and as they entered they were transfigured, and they had Raiment put on that shone like Gold. Then I heard in my dream that all the bells in the City rang again for joy, and that it was said within, Enter ye into the joy of our Lord.

John Bunyan - THE PILGRIM'S PROGRESS

Journeys End

At the gates of the Golden City
By the walls of precious stone
Stands a band of tired pilgrims
Weary from the road

They see a place so beautiful
They see a place so free

And with His arms wide open
To embrace each one
They hear the Father's welcome
As He says 'Well done
You are home, you are home'

Through the gates of the Golden City
Come the keepers of the faith
They're the ones whose hearts were humble
They're the ones who ran the race

They see His face, so beautiful
Shining like the sun

And with His arms wide open
Full of love and pride
They hear the Father's welcome
'Won't you come inside
You are home, you are home'

Who knows from where we've come
Or what our stories are
from North or South, East or West
We all have travelled far

So meet me at the finish line
It's where our journey ends

With the hosts of heaven
Singing endless praise
Yours a crown of glory
For eternal days
You are home, you are home

∘∘∘∘ *Prayer* ∘∘∘∘

Lord, support us all day long of this troublous life,
until the shadows lengthen and the evening comes
and the busy world is hushed,
the fever of life is over and our work is done.
Then, Lord, in Thy mercy, grant us and those we love
safe lodging, and holy reſt and peace at the laſt.

A couple of years ago Maria McKee was at the top of the charts with a song: 'Show me heaven'. Only God can give us a true picture and that is exactly what we get in Jesus.

We know about heaven because of what God has shown us. Not only His promises in the Bible but primarily in Jesus. By Jesus dying and being raised to life we get our surest glimpse of heaven's reality.

There is no room for 'have a nice thought about what your heavenly existence might be like' in Christianity. There is no talk of reincarnation, arriving in heaven and being able to choose to be your favourite animal - a unicorn or hedgehog - there is no airy fairy idea that we become like a little drop in a big ocean, or a blade of grass in a field.

If Jesus being raised to life is the guide to what our life will be beyond our death, there are some extraordinary consequences for our ideas of heaven. First, that just as Jesus was the same person after death as before so will we be. Heaven is not about losing our personality or our identity. Heaven is about becoming more the person you were made to be. You as yourself will not cease to exist when you die.

St Paul talks about our life like a seed, which when we die flourishes into new life. One caterpillar said to another, looking at a butterfly: 'You'll never get me up in one of those!'

Heaven will be so real it's hard to get your head around. But that's why the stories of what Jesus did in days after He rose from the dead are so important. Because they tell us that He ate and drank. He walked and talked. He could be touched and hugged. This is the pattern for what heavenly existence is. Heaven will be physical: we will have bodies, we will talk, laugh and eat. We will recognise each other and enjoy each other's company. One of the main pictures Jesus uses of heaven is of a banquet. Jesus characterises heaven as a place of celebration, parties, dances and feasts. God, who created the world, who paints the sunrise with a flick of His wrist, will keep us occupied for eternity without any problem.

What does this mean for how we should live now?

We don't earn our place, or buy our ticket. It's a free gift in Jesus.

Our response is to let the fact of our final destiny transform how we live in the present.

Our first response is to give ourselves to God who has given us so much and promises us so much in the future.

Jesus encourages us not to live as if this life were everything. While this present life is important, it is not all-important. We don't need to store up things in the here and now, we are freed to be generous and gracious. Don't let this world kid you that all you see is what is of ultimate value.

Jesus is in heaven, not only reigning, not only praying for us, but He is preparing a place for us. He waits for us and will welcome us with joy. Heaven is ready for us. You and I, are we getting ready for Heaven?

Heaven is in the future tense. Today we live in the present tense. To be a Christian means our future is grounded in future reality.

Knowing there's a Heaven can comfort us when life begins to cave in. Heaven reminds us that there is a firm unshakeable shelter above.

Live in the light of eternity. In the words of the folk tune: 'This world is not my home, I'm just a-passin' through.'

J. John

ALSO FROM SOLWAY

The companion recording 'City of Gold'
is available in CD and cassette.

Adrian Plass reads many of the evocative
poems and prose found in the book. These are
accompanied by meditative songs sung by
Julie Costello and Mal Pope to provide a
different dimension to the beauty of this work.

*Available through most Christian bookshops or
by writing directly to: Gold Records, PO BOX 446,
Derby, DE23 7ZU, UK.*

solway

ALSO FROM SOLWAY

The talents of Adrian Plass and Ben Ecclestone
combine to produce a beautiful and
thought-provoking gift-book. *'Learning to Fly'* is a
journey of words and poems by Adrian Plass
interwoven throughout with sketches, paintings
and collages from his friend Ben Ecclestone.

*"Not a book of illustrated poems but a collection of shared
enjoyments, struggles and questions offering laughter and
tears but no easy answers to anything."*
Adrian and Ben

solway